LOST

LOST

Lost and Found
Pet Posters
From Around
the World

Ian Phillips

Published by
Princeton Architectural Press
37 East Seventh Street
New York, New York 10003

For a free catalog of books, call 1.800.722.6657.
Visit our web site at www.papress.com.

Contact information has been masked or altered on many of
the posters to ensure the privacy of the pet owner.

Editor: Jennifer N. Thompson
Design Direction: Evan Schoninger
Designer: Ian Phillips

Special thanks to: Nettie Aljian, Ann Alter, Nicola Bednarek, Janet Behning,
Megan Carey, Penny Chu, Jan Cigliano, Clare Jacobson, Mark Lamster, Nancy
Eklund Later, Linda Lee, Jane Sheinman, Lottchen Shivers, Scott Tennent, and
Deb Wood of Princeton Architectural Press
—Kevin C. Lippert, publisher

Library of Congress Cataloging-in-Publication Data

Phillips, Ian.
 Lost : lost and found pet posters from around the world / Ian Phillips.
 p. cm.
 ISBN 1-56898-337-9 (alk. paper : pbk.)
 1. Posters—Catalogs. 2. Pets—Posters—Catalogs. 3. Pet
loss—Posters—Catalogs. 4. Phillips, Ian—Poster
collections—Catalogs. 5. Posters—Private
collections—Canada—Catalogs. I. Title: Lost and found pet posters
from around the world. II. Title.
NC1764.8.A54 P49 2002
743.6—dc21
 2001007799

Acknowledgments

Thank-you to everyone who contributed posters to the collection over the years. Special thanks to Sonja Ahlers, George Banton, Peter Buchanan-Smith, Patricia Collins, Rachel Crossley, Mike Dyar, Ronald Gonsalves, Grant Heaps, Derek McCormack, Mark Pawson, Julee Peaslee, Stangroom, and Gerardo Yépiz.

About the author

Ian Phillips works as an illustrator and designer for books, magazines, and newspapers. In his spare time he runs a small press. His small hand-bound books are on the shelves of book collectors worldwide and have appeared in galleries from Moscow to San Francisco. He makes his home in Toronto.

Dog Gone

I collect lost pet posters. Each one is a heartbreaking
story about love, loss, and friendship, illustrated with
folksy artwork. Though they're cheaply made and quickly
destroyed, pet owners pour their hearts into them,
exposing deep emotions to an unknown telephone-pole
audience. I own posters that bemoan the loss of
everything from cats and dogs to ferrets and cows.
One poster of a lost dog turns out to be a message from
a jilted lover to her lost boyfriend. "Tell him to call," it
says. Another poster includes only the plaintive plea:
"Turtle. Find him."

As a child, I was allowed to have only small pets like
goldfish or hamsters. The hamsters were forever
breaking out of their cages and running away. But not
too far. It was too snowy in northern Ontario, where I
grew up. I usually found my pets underneath the

refrigerator or living inside the walls, so I never had to put up "missing hamster" posters in my neighborhood.

I started collecting lost pet posters when I was living in Switzerland. My roommate had a cat that climbed out of the window and along the ledge to visit a neighbor's cat. One day "Nava" fell off the roof of our five-story apartment building and disappeared. My distraught roommate put up missing cat posters everywhere in the neighborhood. After a couple of weeks, we received a call. A veterinarian had performed surgery on Nava's broken paws, legs, and jaw. A medical bill for over 3000 Swiss francs had to be paid in order to retrieve the cat. My roommate paid the sum. A few years later Nava ran away from his new home in the country and was never seen again.

I wanted to see what missing pet posters looked like in other parts of the world. I advertised in a variety of zines and contacted a network of friends, family, penpals, and artists. News about my collection spread. Posters began arriving from Australia, Japan, Europe,

and across North and South America. I also received flea collars, dog tags, paintings of chickens, and a lot of letters. One letter from someone in Iceland explained that people in Iceland don't lose their pets and that I would never get a poster from anyone there. Another letter from the Netherlands told me: "We just don't do that sorta thing in Holland. Lose a pet and the thing to do is go out and buy a new one."

This anthology contains my absolute favorite posters. Watch out for a rat named "Poison"; a 10,000 dollar reward; pets lost in bag-snatchings, earthquakes, and carjackings; pets lost by babysitters; Pudding, Piggy, Porky Pie; cats with extra toes; dogs with no legs; Toto, Kitty Lang, Elvis, and Grizzabella.

If you start your own collection, replace posters you remove with new ones: if you remove one, make copies and put ten back.

Meow.

Legend
- 🦅 Bird
- 🐱 Cat
- 🐮 Cow
- 🐕 Dog
- 🦦 Ferret
- 🐹 Hamster
- 🐰 Rabbit
- 🐀 Rat
- 🐍 Snake
- 🐢 Turtle

Population of Missing Pets

Dogs

LOST

OUR DOG WENT MISSING FROM THE BELTON STREET
AND RENO STREET AREA DURING THE AFTERNOON OF
WEDNESDAY, AUGUST 21, 1996. HE IS A TWENTY-TWO
POUND, WHITE BICHON WITH APRICOT COLOURED
EARS. HE IS NOT WEARING HIS COLLAR.

HIS NAME IS T-BONE.

IF HE IS FOUND OR IF HE HAS BEEN SEEN,
PLEASE CONTACT

Nova Scotia

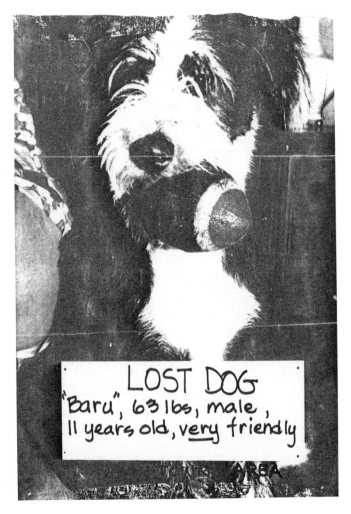

Hawaii

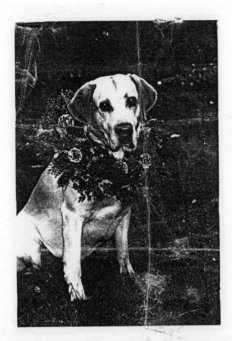

DuNCAN IS MISSING

FRIENDLY YELLOW LAB
8YRS OLD AND 80LBS.

REWARD

Ontario

CANADA

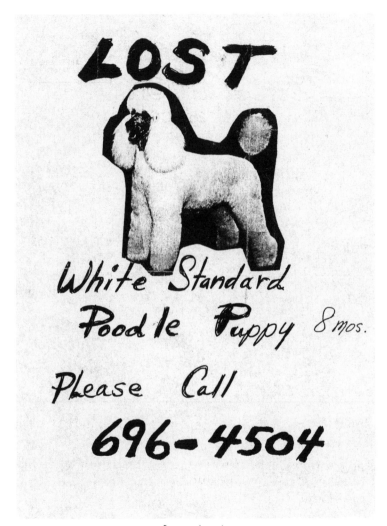

Pennsylvania

USA

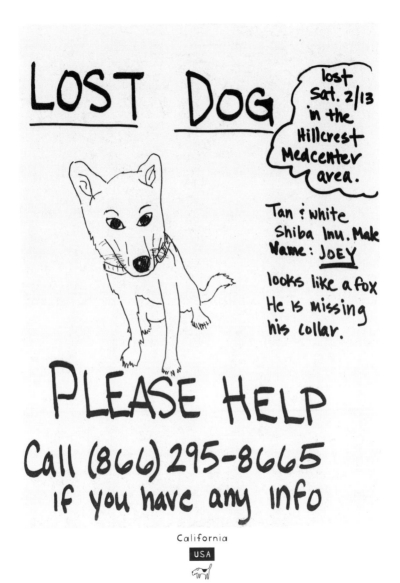

"Natsu"

JAPAN

French Bulldog named Bizet

(black brindle, 33lbs, male)

David, I lost contact. Please call
Deanna at (332)872-5332. If anyone
knows David, pls. tell him to call.
I just want to know how is Bizet doing.
Also, I need to give you Bizet's medical
history. Thank you.

Is this a missing dog poster or a missing boyfriend?

Maryland

USA

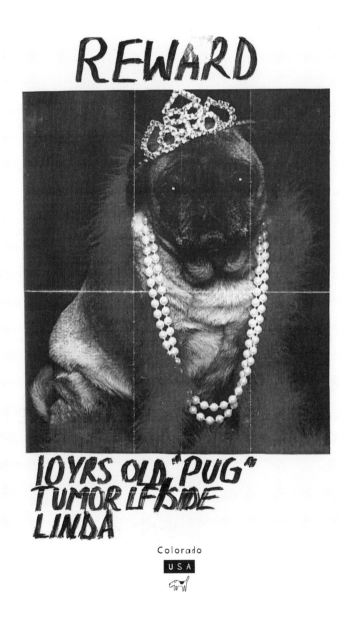

REWARD

10 YRS OLD "PUG"
TUMOR LF SIDE
LINDA

Colorado

USA

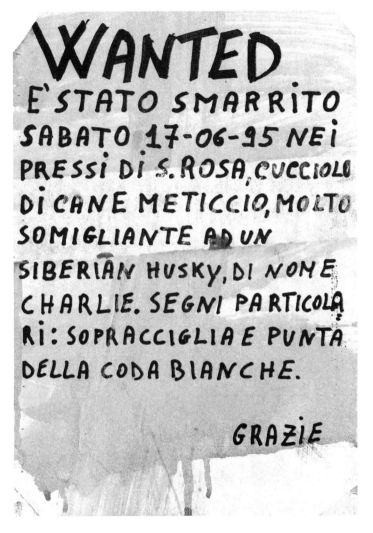

WANTED

E' STATO SMARRITO
SABATO 17-06-95 NEI
PRESSI DI S. ROSA, CUCCIOLO
DI CANE METICCIO, MOLTO
SOMIGLIANTE AD UN
SIBERIAN HUSKY, DI NOME
CHARLIE. SEGNI PARTICOLA
RI: SOPRACCIGLIA E PUNTA
DELLA CODA BIANCHE.

GRAZIE

ITALY

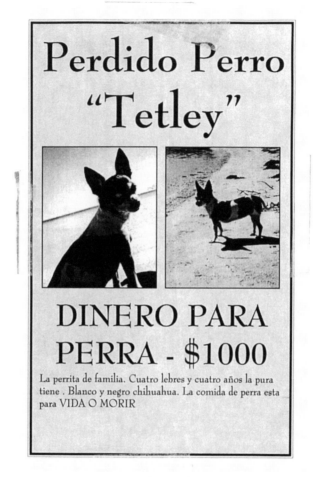

Perdido Perro "Tetley"

DINERO PARA PERRA - $1000

La perrita de familia. Cuatro lebres y cuatro años la pura tiene . Blanco y negro chihuahua. La comida de perra esta para VIDA O MORIR

This dog appeared on the cover of "New York Newsday" with the headline: "Heartless subway thief steals duffel bag bearing beloved pet chihuahua."

New York

USA

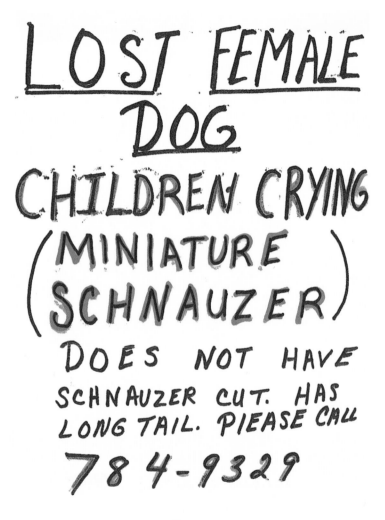

LOST FEMALE DOG

CHILDREN CRYING (MINIATURE SCHNAUZER) DOES NOT HAVE SCHNAUZER CUT. HAS LONG TAIL. PLEASE CALL

784-9329

Texas
USA

LITTLE
DOG

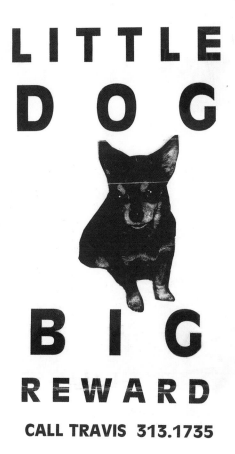

BIG
REWARD

CALL TRAVIS 313.1735

California

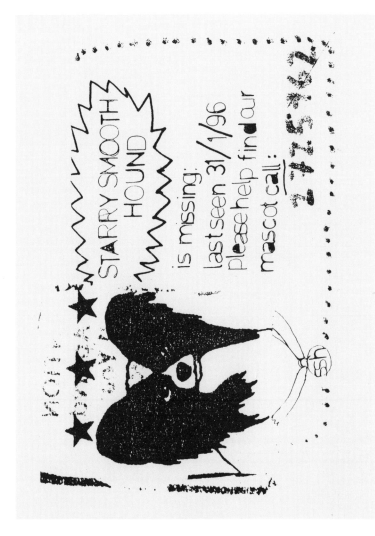

ENGLAND

DESAPARECEU

CÃO DE RAÇA "FOX-TERRIER", PÊLO CASTANHO E BRANCO, DESAPARECEU DE SUA CASA NA RUA DO PINHAL - LIVRAMENTO - S. JOÃO ESTORIL - NA TARDE DE DOMINGO DIA 7 DE MARÇO.

TEM COLEIRA COM O NOME "SMARTY" E Nº DE TELEFONE 4671573 OU 4686917.

DÃO-SE ALVISSARAS A QUEM ENCONTRAR OU INDICAR PARADEIRO.

PORTUGAL

LOST BLACK LAB

No Collar, No Legs,

NEEDS Medicine!!!

Call 334-5015

Ask for Unca Tom Jennings

Florida
USA

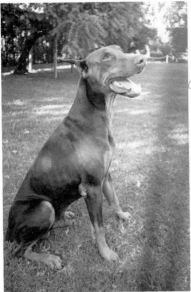

Indio - Doberman
de 4 años - cariñoso
con los dueños.
muy agresivo con
los extraños -

Rte -
Susana Gatti
Rioja 1241 - Piso 10 -
T E 407 155
2.000 Rosario -
Santa Fe
Rp. Argentina -

ARGENTINA

STOLEN DOG

PLEASE CAN YOU HELP?

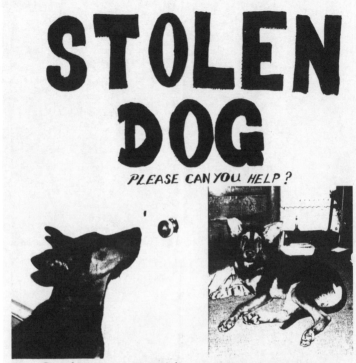

ONE YEAR OLD ZAK WAS TAKEN FROM OUTSIDE THE RUSHOLME KWIK SAVE ON THE 4th JUNE AT 4pm. HE IS A VERY LARGE DOBERMAN/GERMAN SHEPHERD, BLACK+TAN, WITH EXCEPTIONALLY LARGE EARS. IF YOU HAVE SEEN HIM, OR HAVE ANY INFORMATION TO HIS WHEREABOUTS PLEASE RING

A REWARD WILL BE GIVEN FOR HIS SAFE RETURN.

ENGLAND

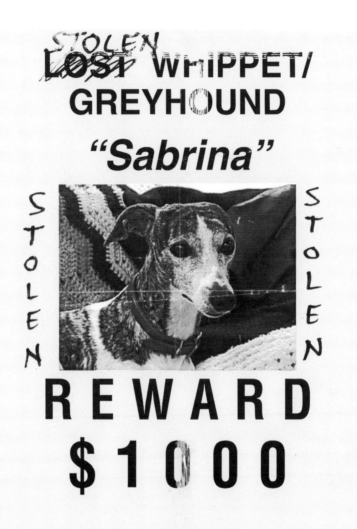

S T O L E N

Monday, 28th of June

Staffordshire bull

terrier-FROM HIGHGATE VILLAGE

£1000 Cash reward -

For her safe return .
DESCRIPTION- Large female .
Brindle with white markings
under her neck and on her chin
2 years old.
ANSWERS TO BO-BO

P L E A S E H E L P .

ENGLAND

LOST DOG
NAME "LADY"
$100.00
REWARD

FOR INFORMATION LEADING TO THE RECOVERY OF THIS OWNERS' PET.

DETAILS:

LADY WAS LOST IN THE ROXBOROUGH & YONGE ST. AREA JUNE 28/92.
I HAVE SPOKEN TO SOME OF THE RESIDENTS IN THE IMMEDIATE AREA
WHO ARE POSITIVE THAT THEY HAVE SEEN THIS DOG WITH ANOTHER
COUPLE WHO DO NOT FRATERNIZE WITH OTHER DOG OWNERS IN YOUR
AREA. I HAVE BEEN TOLD THAT THIS DOG IS NEW TO YOUR AREA AND
I ASK THAT YOU KEEP A CAREFUL WATCH FOR HER, PLEASE.

DESCRIPTION:

LADY IS 3 YEARS OLD AND WEIGHS APPROX. 50 TO 60 LBS. SHE IS
OF THE SHEPPARD COLLIE VARIETY WITH A BLOND COAT AND A WHITE
UNDERBELLY. SHE ALSO HAS WHITE MARKINGS ON ALL OF HER FEET.
LADY IS A VERY LOVING ANIMAL WHO LOVES TO BE AROUND PEOPLE
AND THRIVES ON CONSTANT ATTENTION. SHE DOES NOT BITE, BARK
OR GROWL AND IS VERY WELL TRAINED AND LISTENS VERY WELL.

Ontario

CANADA

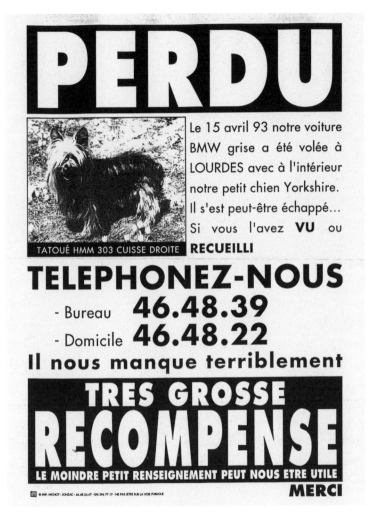

This Yorkshire puppy was sitting in the back seat of the owners stolen BMW.

FRANCE

LOST DOG: "GRACIE"

85 lbs. Female, Black And Tan Doberman

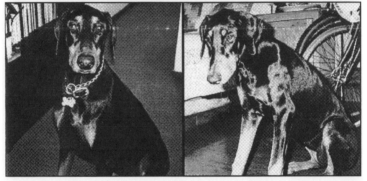

HUGE REWARD!

Last Seen The Morning Of 7-18-97
At 52ND AND KIMBARK

Gracie Foiled An Attempted Burglary, But Then Chased The Would-Be-Robber Into The Streets

Illinois

USA

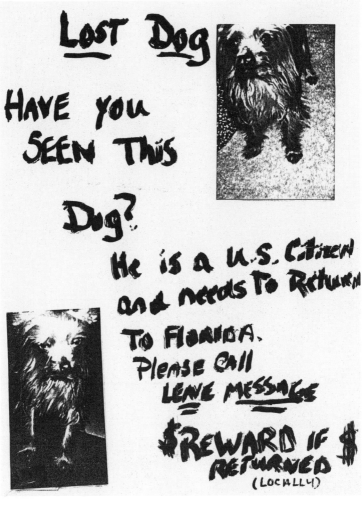

Lost Dog

Have you seen this Dog?

He is a U.S. Citizen and needs to Return to Florida. Please Call Leave Message

$ Reward if $ Returned (Locally)

Ontario
CANADA

LOST DOG
COCKER SPANIEL TYPE
MISSING 2/28/95
PLEASE HELP - TOTO IS BLIND

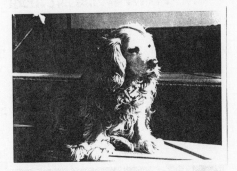

**She's about 18" tall, no tail, blond/red wavy
hair, 12 years old.
Red cloth collar, Rabies Tag #1047.
Address: 168 Walter Street**

Toto was lost during a snowstorm. She was eventually found, alive and well.

Massachusetts

U S A

RECOMPENSA
DE $1000.00
POR ENCUENTRO DEL PERRO BENJI

Benji tiene pelo greñudo de color beige.
Mas o menos pesa ocho kilos y mide 60 cm
de largo por 30 cm de alto. Benji es de tipo
Terrier Tibetano y parece igualito al Benji
de la pelicula Disney de su nombre. Si tiene
información sobre Benji, llame al telefono

"Stretch" Was Stolen, April 6, 1996

PLEASE Don't Remove this poster or dis it.

Female
Daschound
"Weiner Dog"
Pedigreed

Very small
Looks like "pup"

Tiny,
Answers to
Name "Stretch"

Red Hair -
Short Dk.

.

Still Missing
April 21, 1996

Cutest dog in
NYC
8 lbs

Small Feet

Stolen Dog ("Stretch")
$600 Cash Reward

Stolen Daschound (weiner dog) named "Stretch". Red color,
short hair, female, unspayed, 1 1/2 yrs. old. Miniature size, 8 lbs.
Pedigree. Taken by two hispanic males, approx 19 years old.

Dog stolen early Saturday morning April 6, 1996

from 105th and Broadway, possibly sold on street, Through newspaper ad,
or abandoned, at any city location. STILL MISSING!

NO QUESTIONS ASKED

Please Help if you have information about Stretch, my soulmate.

New York

USA

¡¡¡PERDIDO!!!

PERRO PEQUINÉS ALBINO
RESPONDE AL NOMBRE DE YACKY.
29/4/98 TARDE

TELF. DE CONTACTO: **459 33 11 (MAÑANAS)**
207 36 25 (TARDES)

LOST DOG DUE TO CARJACKING IN S.F. 6/13/94

Man, woman sought in carjacking

SAN FRANCISCO Police are looking for a man and a woman who stole a Pontiac Transam from its owner at gunpoint, making off with the car and the owner's 10-year-old dog, Cleo.

The carjacking occurred Monday afternoon at 16th Street and Potrero Avenue, Sgt. Barbara Davis said. The owner told police he had been in his parked car when a man opened the unlocked passenger door, slid in and told him at gunpoint to get out.

As the owner climbed out of the 1982 black Transam, a woman climbed in the passenger side, and the couple sped off, with Cleo the Sharpei sitting in the back seat.

The car has a California license plate of 2MXW233. Cleo is fawn-colored, with a dark brown circle on her left hind quarter.

Compiled from Examiner staff and wire reports

NAME: CLEO
BREED: SHAR PEI
AGE: 10 YRS OLD
DESCRIPTION: Brown with small
dark-brown circle on left side.
Animal friendly/people shy

California

USA

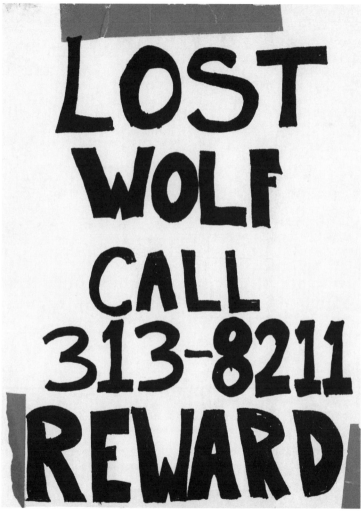

Idaho

USA

$1,000
REWARD

NO QUESTIONS ASKED

To the person who has Teddy: I know he is irresistibly adorable, but he is more than that to me--he is like a son. My life has been absolute torment since he disappeared. Every time I walk through my front door into an empty house my heart breaks a little more and tears stream down my face. He has been my best friend for nearly 7 years...

"TEDDY"

LOST 2/7
6 YR. OLD NEUTERED
MALE BICHON FRISÉ
WHITE CURLY HAIR
BROWN EYES & NOSE

PLEASE BRING HIM
HOME

IF YOU HAVE TEDDY OR SUSPECT YOU KNOW WHO DOES
PLEASE CALL ME

549-3549

California

USA

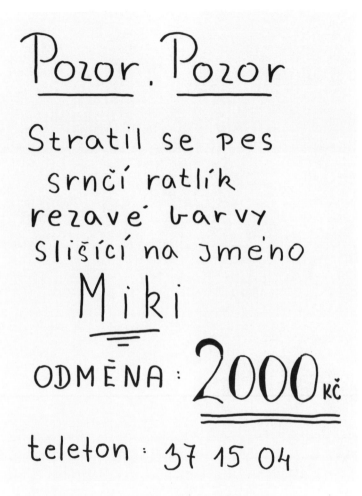

Pozor, Pozor

Stratil se pes
srnčí ratlík
rezavé barvy
slišící na jméno
Miki

ODMĚNA: 2000 kč

telefon: 37 15 04

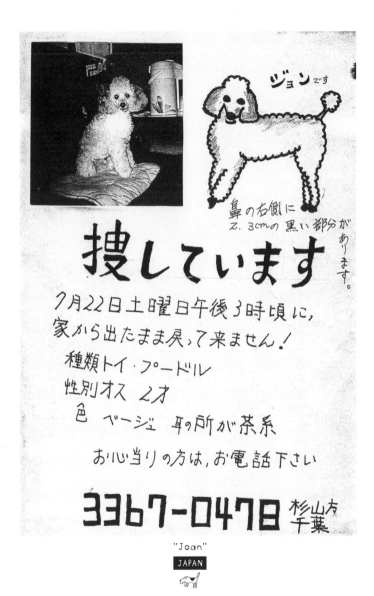

"Joan"
JAPAN

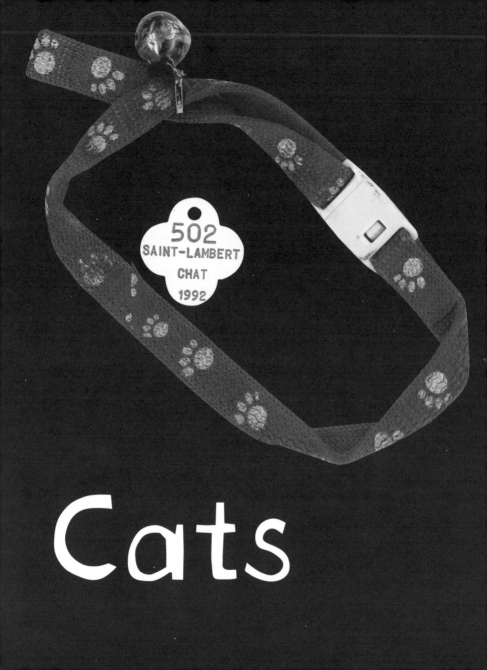

Cats

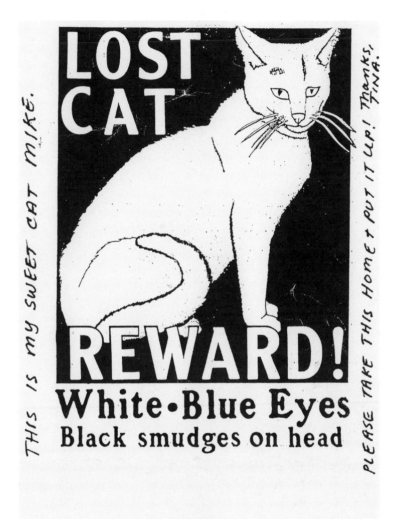

Michigan

USA

WANTED:

$50
reward

$50 —
reward

if found.

LOST CAT

Female tabby, rotund (14lbs)
"Pudding" 10 yr old
front/back claws

Lost on Saturday the 13th of Jan.
around the 3rd st/ciberty intersection 1996.
if found, call John Heider
339 3rd St A^2.

No collar, as she's normally inside.

Michigan
USA

ELVIS IS MISSING!!

He's a male CROSS Siamese, very friendly cat. He needs medical attention now! Reward!! Last seen July 11th on E. CHRISTINA St. Call Suzanne 622-4911 or 622-277 THANK-YOU

Ontario

CANADA

LOST CAT

It is a half Persian cat and half tabby. It has a fluffy tail. It has no coller. If you find this cat Please return it to 10 minogue units. Thank you. Please find my home.

it him
s the
rden

STOP

Find my
home

Neighborhood News

© 1993 by Friends of Twerp; Phone: 525-0608

MISSING KITTEN!

WANDERLUST HITS 5 MONTH OLD KITTY

In a daring midweek escape, a clever 5 month old tabby kitten has left the home of his owner, Bob Jacoby, at 801 N.E. 98th Street in the Maple Leaf neighborhood of Seattle. The kitty is now at large, and is charming (or terrorizing) this formerly peaceful neighborhood.

The daring getaway occurred some time around Thursday, November 11th. The kitty, known as "Twerp", is a black and brown 5 month old male tabby, possibly wearing a flea collar (unless he has ditched it).

According to the owner, Twerp has a strange affinity for bath tubs and toilet bowls, watching the water swirl around and disappear down the drain before his eyes. Balloons, pieces of string, and socks are all in jeopardy when this cute little terror-meister is nearby!

A recent photo of "Twerp", obviously studying one of his potential escape routes.

LAST SEEN NEAR 97TH AND ROOSEVELT WAY

Twerp was later sighted near 98th and Roosevelt Way, where he watched and lent moral support for several hours to a man working on his car.

Twerp later sought refuge at the Legend House Apartments at 97th and Roosevelt Way, where he had charmed

his way into one of the apartments. He was content to stay there for several days until wanderlust hit again, and he disappeared some time during Tuesday, November 16th.

His owner, Bob Jacoby, had just finally been able to make contact with

the woman in the apartment, only to find that the clever Twerp had slipped out that afternoon! "That little rascal is going to have an I.D. collar on him as soon as I find him!" exclaimed Mr. Jacoby as he headed out into the night on another search party.

If you see this kitty, please call Bob Jacoby

Washington

USA

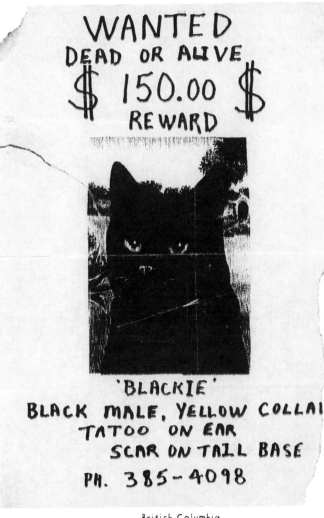

WANTED
DEAD OR ALIVE
$ 150.00 $
REWARD

'BLACKIE'
BLACK MALE, YELLOW COLLAR
TATOO ON EAR
SCAR ON TAIL BASE
PH. 385-4098

British Columbia

CANADA

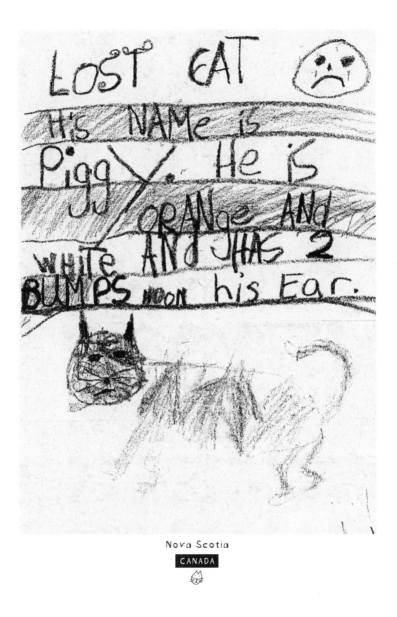

Nova Scotia

CANADA

LOST

"PORKY PIE"

BLACK CAT

LOVED 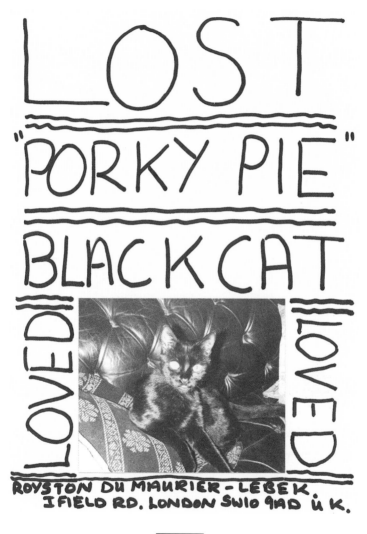 LOVED

ROYSTON DU MAURIER - LEBEK.
3 FIELD RD. LONDON SW10 9MD U K.

ENGLAND

This "pussy" has "four pairs of breasts... the temperament of a tiger... rarely purrs, and likes to scratch children."

FRANCE

Have you scene my CAT?

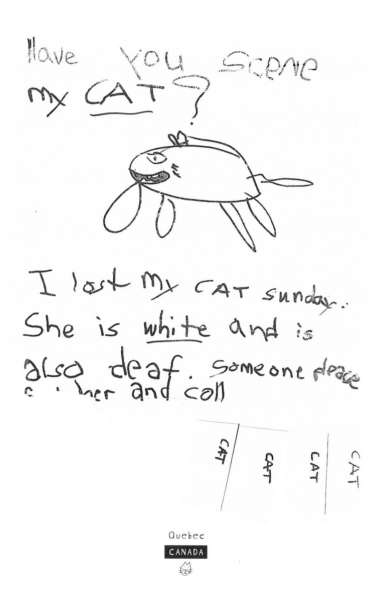

I lost my CAT sunday.
She is white and is
also deaf. someone please
c_ her and coll

CAT CAT CAT CAT

Quebec
CANADA

Lost Cat

Name: Ringer

Description: tabby color
Ring tail
Affectionate

I Really miss him
and I would like him home
for Xmas.

thank You

Ontario
CANADA

Lost Cat

orange cat lost
Male 3-4 years Old
Please phone: 2 74-736

Ceasar

Quebec
CANADA

I'm lost!!
Last seen 2-23-95
near Boyd,
Clifton, Cavour Ave

My name is
Sammy. I
survived the Northridge earthquake.
Please help me survive this.

Check your basement or
garage. I'm friendly.

I'm black + white, shorthair,
1½ yrs. old, "tuxedo" markings.
My owner loves me.

REWARD!

California

U S A

MISSING SINCE SEPTEMBER 13

HAVE YOU SEEN TAWNY, OUR MUCH LOVED MISSING CAT?

Note: On September 20 he was spotted on Howland Avenue, possibly with an injured leg.

Please check garages, and anywhere he could be hiding. Thank you!

DESCRIPTION:

LARGE TABBY - APPROXIMATELY 10 YEARS OLD; ORANGEY/BEIGE WITH WHITE SPOT ON BACK; WHITE PAWS; MEDIUM HAIR; BLUE COLLAR WITH 2 KEW BEACH VET TAGS

He was staying at a friends home, (Dupont/Spadina Rd.) while we were away and may be trying to get home (the beaches). He is shy and is probably very scared. We miss him very much - please help.

WE ARE OFFERING A $100.00 REWARD FOR INFORMATION LEADING TO HIS SAFE RETURN.

Ontario

CANADA

CLEO THE CAT ABDUCTED!!

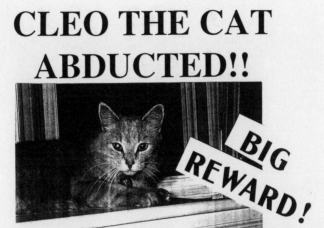

Cleo is a honey-coloured, mature cat, very fluffy, and has

NO TAIL

She was picked up in a car from College and Beverly Streets on July 21

Cleo is on a restricted diet because of a health problem. She is loved very much and missed terribly

Please help us find Cleo

Ontario

CANADA

LOST CAT

AN OLD AND TOOTHLESS, ORANGE
PERSIAN WITH A DANDRIFF PROBLE
AND A FLAT FACE 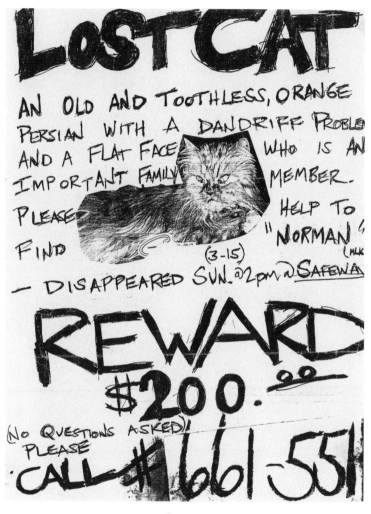 WHO IS AN
IMPORTANT FAMILY MEMBER.
PLEASE HELP TO
FIND "NORMAN"(MLK
(3-15)
— DISAPPEARED SUN. @ 2 PM ~ SAFEWA

REWARD
$200.⁰⁰

(NO QUESTIONS ASKED)
PLEASE
CALL # 661-551

Oregon

USA

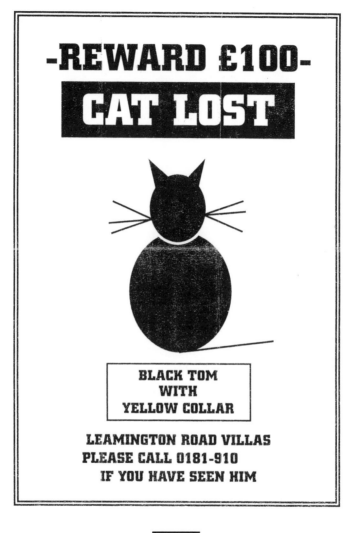

-REWARD £100-
CAT LOST

**BLACK TOM
WITH
YELLOW COLLAR**

**LEAMINGTON ROAD VILLAS
PLEASE CALL 0181-910
IF YOU HAVE SEEN HIM**

ENGLAND

Wir Vermissen
unser Kätzchen
seit dem 21. 4. 96.
Sie ist ganz schwarz
mit einem weissen
fleck auf der Brust.
Ihr Name ist Puspas. Evtl.
Ist sie in einem estrich, da sie
übers Dach der Klybeckstr. 78
weggegangen ist. Bitte
schaut überall nach. Danke.

"Her name is Puss Puss"

SWITZERLAND

LOST CAT
during Earthquake

NAME: FELIX (male)
Color: Grey with light grey stripes. 8 pounds. Brown Colar, NO TAGS

OWNER Misses Him VERY MUCH. PLEASE CALL

$ $ REWARD $ $

California
USA

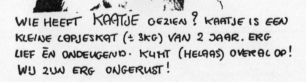

WIE HEEFT KAATJE GEZIEN? KAATJE IS EEN KLEINE COPJESKAT (± 3KG) VAN 2 JAAR. ERG LIEF EN ONDEUGEND. KUHT (HELAAS) OVERAL OP! WIJ ZIJN ERG ONGERUST!

Before this poster appeared, others of the same cat asked neighbors not to feed her because of her strict diet. She was found dead a week later. She'd been hit by a car and died in the bushes.

THE NETHERLANDS

LOST

BLACK &
WHITE
CAT

WITH A FEW EXTRA FRONT TOES

PLEASE TAKE A LOOK
IN YOUR GARAGE OR SHED

IF YOU FIND SCOOTER PLEASE CALL
ADAM

Ontario
CANADA

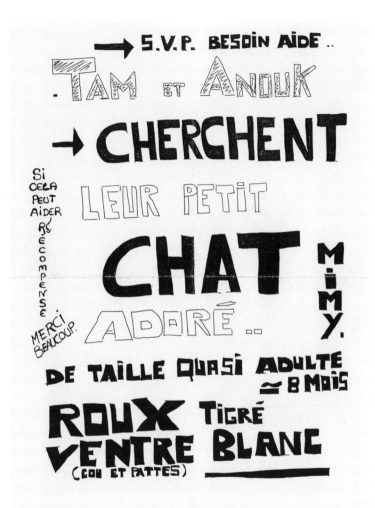

→ S.V.P. BESOIN AIDE ..

.TAM et ANOUK

→ CHERCHENT

LEUR PETIT

CHAT

MIMY.

SI CELA PEUT AIDER → RÉCOMPENSE

MERCI BEAUCOUP.

ADORÉ ..

DE TAILLE QUASI ADULTE ≃ 8 MOIS

ROUX TIGRÉ
VENTRE BLANC
(COU ET PATTES)

This is Jerry
also called" big fat kitty "
went astray on Mon.March 29th
Dupont / Spadina area.

If found please call

$50.00 Reward

Ontario
CANADA

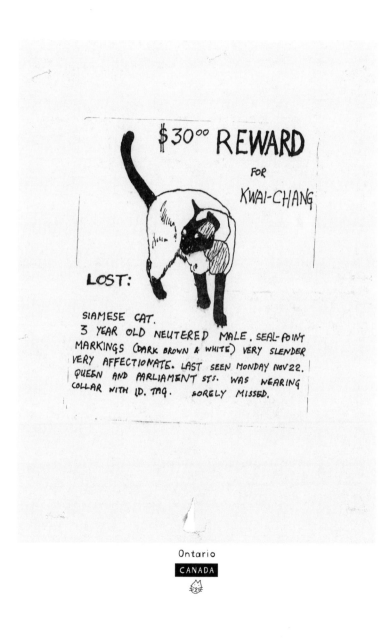

$30⁰⁰ REWARD

FOR

KWAI-CHANG

LOST:

SIAMESE CAT.
3 YEAR OLD NEUTERED MALE. SEAL-POINT
MARKINGS (DARK BROWN & WHITE) VERY SLENDER
VERY AFFECTIONATE. LAST SEEN MONDAY NOV 22.
QUEEN AND PARLIAMENT STS. WAS WEARING
COLLAR WITH I.D. TAG. SORELY MISSED.

Ontario
CANADA

CHALUT!

Je m'appelle **GUMMO**, je suis un **européen noir et blanc de 5 ans avec un collier rouge** et j'habite à proximité du **square d'Alleray**.

Je suis câlin et farceur, d'ailleurs je ne suis pas rentré à la maison depuis le 26 juin dernier et mes maîtres s'inquiètent, alors si vous m'apercevez, s'il vous plaît, dites-leur…

Téléphone 48 56 17

MERCI!

"My name is Gummo."

FRANCE

WANTED

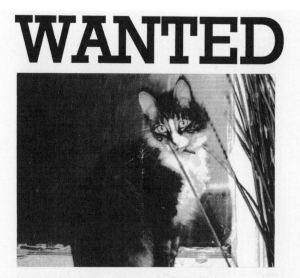

Have you seen Cornelius? He has been
missing since Tuesday, September 22nd.

Cornelius is on medication and must be
treated immediately or he will die!

You will recognize Cornelius as having
been a fixture at Yonge and St. Clair
for many years.

Description: He is a medium sized gray
tabby with white paws and white chest.
He has no tail and walks with a slight
swagger.

If you have any
information to
help Cornelius
get home safely
please contact

Ontario
CANADA

MISSING

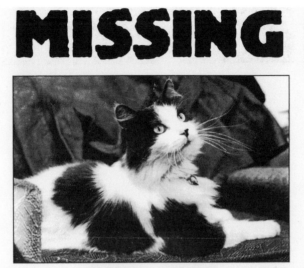

KITTY LANG,

Xtra's office cat, has been missing since Wednesday, March 15th. She is a gray & white long-haired domestic and is wearing a blue identification tag. If you've seen her or have any idea as to her whereabouts, please contact Xtra

Kitty Lang came back a year later, well groomed and overweight, with a second cat. Since a new office cat had taken residence, Kitty moved out to the country farm of a relative of one employee and the second cat was adopted by another.

Ontario

CANADA

~~ST CAT~~

GINGER HAS BEEN FOUND!
Thanks For Your Help.

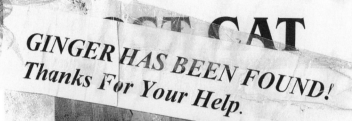

GINGER (left)

Ginger is an orange tabby cat & weighs ten pounds. He is very friendly and greatly missed. Ginger lives in the Brunswick – Ulster area. If you have any information please phone $100. reward for his safe return.

$100 REWARD

Ontario

CANADA

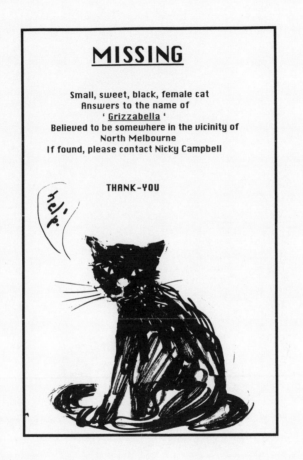

Grizzabella was the name of "The Glamour Cat"
in the Broadway musical "Cats"

He likes to drink from faucets, has

white feet, with one pink paw pad (on a rear foot) and is an adult gray tiger cat with a white bib and belly. He was wearing a flea collar when he wandered off Mon., July 24, from Franklin St., Cambridge, near Putnam.

He is not a stray, and we miss him. If you see him, please give Fred a call at 975-0975. His name is Pushkin.

Massachusetts

USA

黑白短毛猫
遺失抱黑2:
片打柬街 503 號

找们猴現話致電

想他報消刊,也也也

British Columbia

CANADA

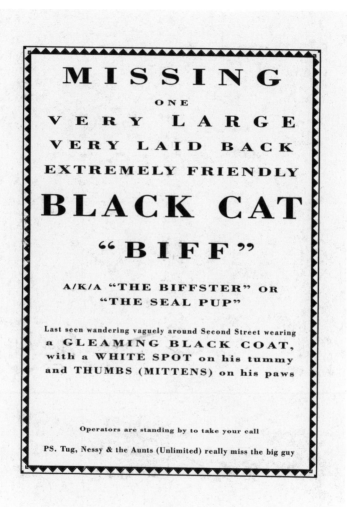

MISSING

ONE

VERY LARGE

VERY LAID BACK

EXTREMELY FRIENDLY

BLACK CAT

"BIFF"

A/K/A "THE BIFFSTER" OR "THE SEAL PUP"

Last seen wandering vaguely around Second Street wearing **a GLEAMING BLACK COAT,** with a **WHITE SPOT** on his tummy and **THUMBS (MITTENS)** on his paws

Operators are standing by to take your call

PS. Tug, Nessy & the Aunts (Unlimited) really miss the big guy

Ontario

CANADA

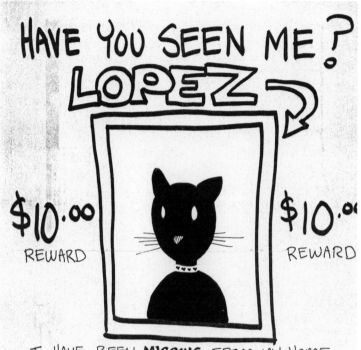

HAVE YOU SEEN ME?
LOPEZ?

$10.00 REWARD

$10.00 REWARD

I HAVE BEEN **MISSING** FROM MY HOME OF **223 AVE. E NORTH** SINCE SUN. ARRIL 10th. I AM COMPLETLY **BLACK** WITH A WHITE COLLAR WITH BLACK HEARTS ON IT. I ALSO HAVE A SMALL FRACTURE IN MY TAIL. MY OWNERS LOVE ME **VERY** MUCH.

British Columbia

CANADA

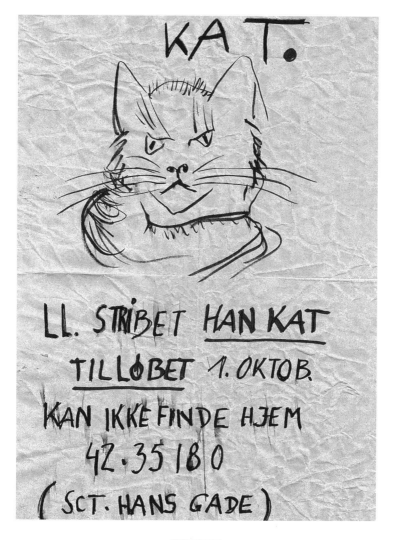

KA T.

LL. STRIBET HAN KAT
TILLØBET 1. OKTOB.
KAN IKKE FINDE HJEM
42·35 18 0
(SCT. HANS GADE)

CAT FOUND
Siamese

11-26-94

In order to safeguard the welfare of the cat and ensure that it is returned to it's rightful owner, the person claiming ownership of the cat will be required to provide: five (5) forms of identification and references including but not limited to, verifiable telephone number and place of occupation. Also, a very specific physical description and photo must be given before return. I will personally check up on the cat at a later date.

California

USA

STILL
MISSING.
TAKE
PHOTO IF
NECESSARY,

THIS
ONE
FOUND
OK!

HAVE YOU SEEN
THIS CAT?

I was away for a month and returned
to find out the sitter lost them. Please
phone if you have, or have seen, my
much loved pal. Thanks!

Ontario
CANADA

Missing since Dec. 24/97. Himalyan Rag-Doll cat.
Very Friendly. (Like long-haired Siamese). Near
peanut pond. House-fire may have frightened her.
Much loved family pet. 9 years old. Reward. #4
 May have
inadvertantly got locked in garage or garden shed.
 Thank You. White stripe
 under chin.

British Columbia

CANADA

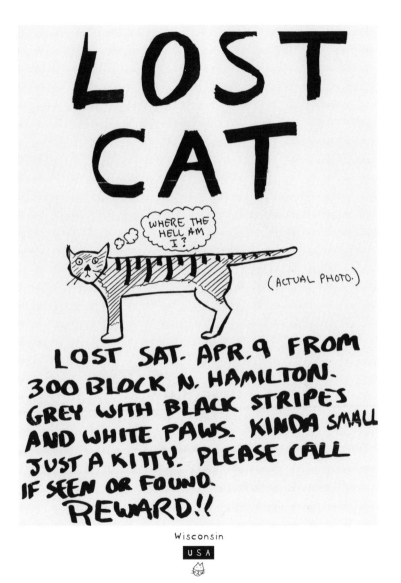

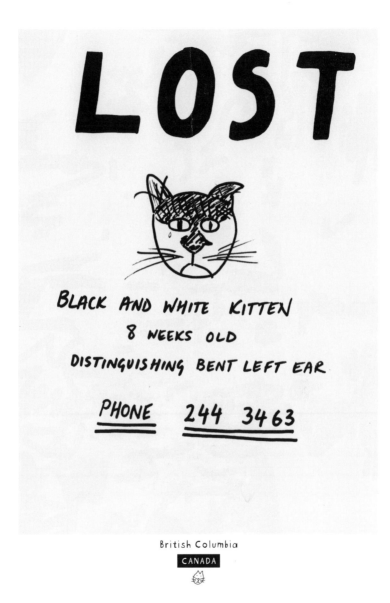

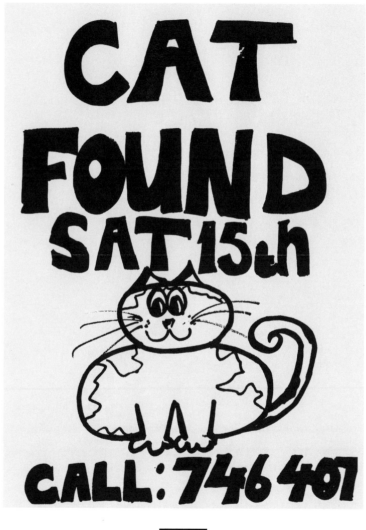

ENGLAND

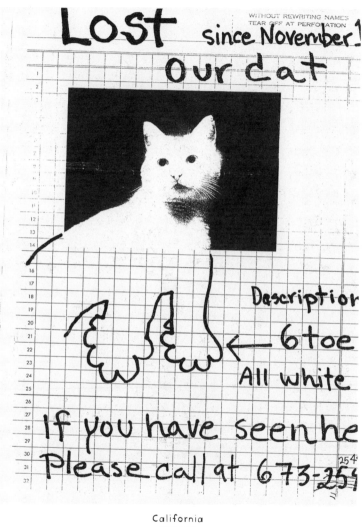

California

USA

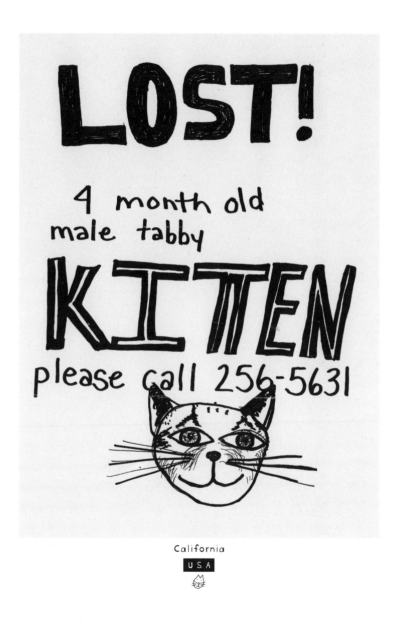

California

USA

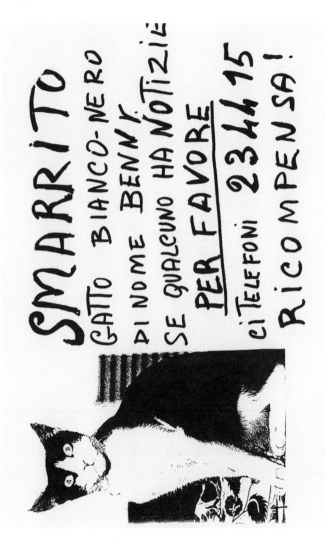

SMARRITO

GATTO BIANCO-NERO
DI NOME BENNY.
SE QUALCUNO HA NOTIZIE
PER FAVORE
CI TELEFONI 23 44 15
RICOMPENSA!

ITALY

˚LOST KITTY˚

Little
pink
scar
on
ear

"JOHNNY"

X-tra long
striped
tail

maybe
part
siamese

Striped
legs
black toe pad

WHITE
WHISKERS

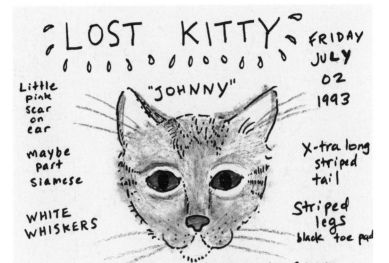

I am a little stray tomcat - cream
body w/ brown-gray points + a very long
striped tail. Blue eyes, and a nose the
coler of a pink pencil eraser. I am friendly,
not quite a year old. I have only been
adopted for 4 days. I just got all my shots,
and was supposed to get my male cat
operation, so I ran away Thursday night
when nobody was home.
Please call Brad or Sarah

782-2412

THANK YOU

Washington

USA

M'avez-vous vu ?

Mon nom est Pico
Grosse bedaine blanche
Pas de collier

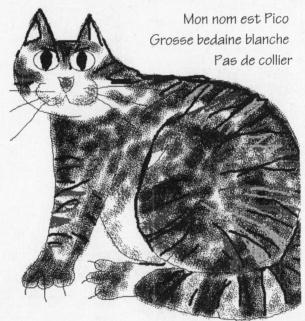

Quebec

CANADA

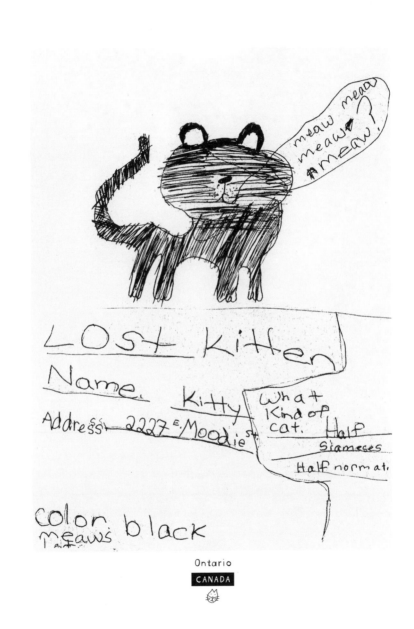

Ontario
CANADA

Birds

LOST
LOST
LOST

one
brown and white 'mottled'
street duck

Does not answer
to the name of
Neither Norman

if found
please call
Three Artists and a (Duck)

New Brunswick

CANADA

$200 REWARD

For any information
leading to the return
of my bird to me.

LOST

All white

COCKATIEL

orange cheeks

yellow crown.

Answers to the name
"Spanky"

Call:
662-4252

California

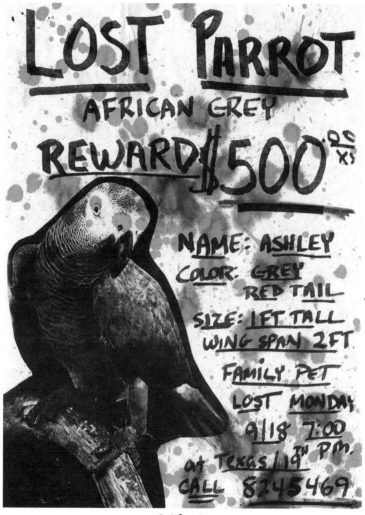

LOST PARROT
AFRICAN GREY
REWARD $500.00

NAME: ASHLEY
COLOR: GREY
RED TAIL
SIZE: 1 FT TALL
WING SPAN 2 FT
FAMILY PET
LOST MONDAY
9/18 7:00 PM
at Texas/19TH
CALL 8245469

California

LOST BIRD

WANTED

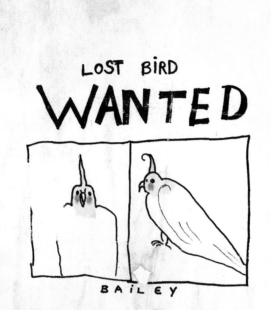

BAILEY

ESCAPED COCKATIEL, MALE
WHITE, PALE YELLOW HEAD, RED SPOTS
LOST SATURDAY, JUNE 8, AROUND 6 P.M.
NEAR SHERBOURNE + ESPLANADE
WE ARE VERY WORRIED ABOUT HIS SAFETY
AND WOULD APPRECIATE ANY INFORMATION

Ontario

CANADA

LOST

<u>HARRIS HAWK</u>

Juvenile (Male) Harris Hawk lost
on Ranmore Common.

<u>Description:</u>
Red/Brown colour. Large Yellow Feet
Mottled Brown/white on chest.
Distinctive tail,Dark Brown with White
tip and underside. Bells and Flying
Jesses' on both legs.

He is very tame, but scared of Dogs. If seen
or heard <u>PLEASE RING</u> Sandy.

885913

ENGLAND

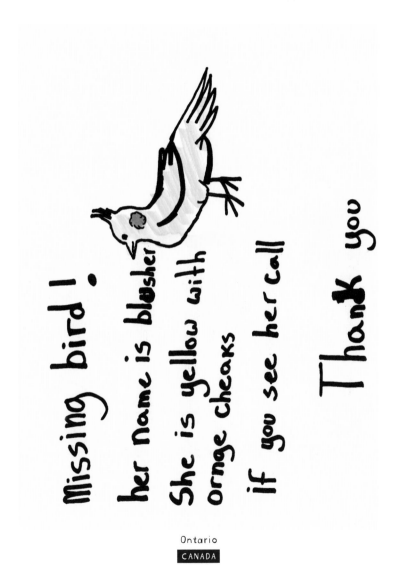

Missing bird !

her name is blusher

She is yellow with ornge cheaks

if you see her call

Thank you

Ontario
CANADA

PARROT STOLEN

Our very well loved Spectacled Amazon parrot, Pegasus, was stolen July 3rd at approximately 5:50 p.m. from Spectrum Exotic Birds where she was being boarded during our vacation. She is about 7" from tail tip to the top of her head and primarily green with white above her beak and red around her eyes and has some red coloring on her tail feathers.

Unless you have lost a pet you cannot understand our sense of loss, grief and fear for her safety and wellbeing. She had been a part of our family for five years.

If you know anyone who suddenly acquired a bird of this description after the above date, please call us at 928-5823. Leave a message if the machine is on. You may leave an anonymous message or leave your name as a reward for her recovery will be paid. Please leave enough information to allow us to investigate whether or not the bird in question is our Pegasus.

California

USA

LOST BIRD

YELLOW COCKATIEL WITH RED CHEEKS

NAME: "BIRDY"
LEASE CALL
⭐ REWARD ⭐

Massachusetts
USA

LOST "#50⁰⁰ Reward"
2 Hand TAMED "Love Birds"
Apr-14-99 7:00 PM

NORTH Park Cleaners
PLS CONTACT
 Johnny * 528-8255
 Nancy * 284-5239
 * Day or Night

California

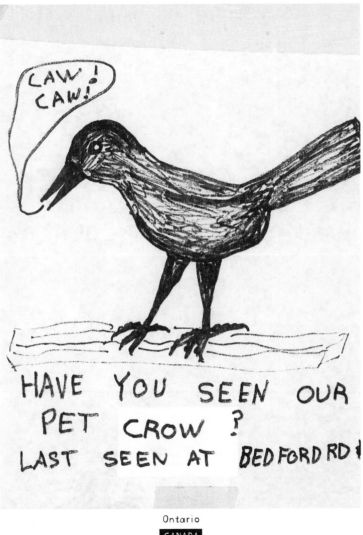

Ontario

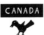

Others

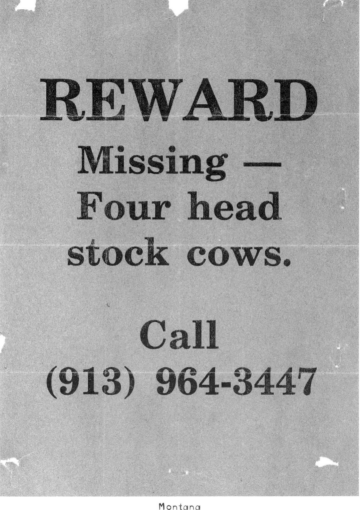

REWARD

Missing —
Four head
stock cows.

Call
(913) 964-3447

Montana
USA

RIND ENTLAUFEN

Am Abend vom Sonntag, 16. Februar
auf den Montag, 17. Februar
ist uns ein Rind entlaufen.

Es hört auf den Namen Lucien und hält sich mit
Vorliebe in Restaurationsbetrieben auf.
Wenn Sie das Rind finden, bitte sofort Tel. 274'04
anrufen. Der Viehtransporter kommt unverzüglich.

VORSICHT BSE-GEFAHR

This is for a lost cow named Lucien.

Hamster Found

a hamster was found wednesday, july 5 on 'spring garden road'. owner please call:

Lisa 835-6690

Nova Scotia

CANADA

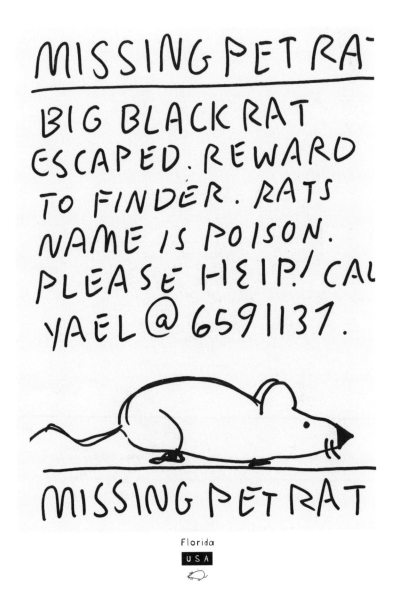

MISSING PET RAT

BIG BLACK RAT ESCAPED. REWARD TO FINDER. RATS NAME IS POISON. PLEASE HELP! CALL YAEL @ 6591137.

MISSING PET RAT

Florida

USA

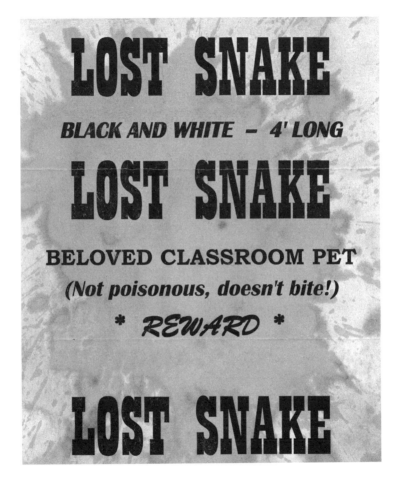

California

USA

HELP, I'M LOST! 11/27

← 3½ FT →

My name is "BO" & I am a king snake. My owner surely misses me as much as I miss him. I swear I didn't mean to get lost, it just sorta happened. If you see me around campus, please call my owner Vick Itone & tell him where I'm located. I am sure my owner will gladly provide a reward. Thanks, Bo.

California

USA

Found :
Domestic
(Rabbit)

6/7/94

Tan with dark nose

Call to reclaim or

Available for adoption to
responsible, permanent home

Pennsylvania

U S A

Si vous trouve
un lapin comme ça
avec les tache
brun appelez

474573

S.V.P.

(vivant ou mort)

"(Alive or dead)"

FRANCE

IF YOU LOST A
TURTLE OR KNOW
SOMEONE WHO
DID.
CALL 864-4792

California

USA

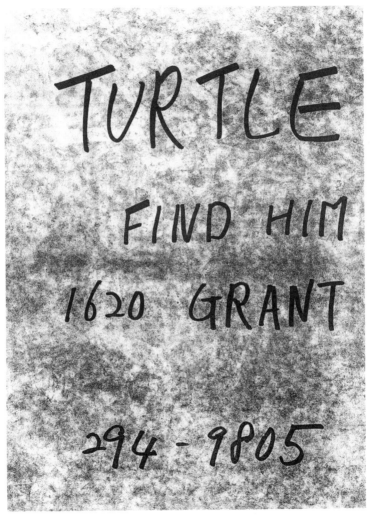

TURTLE

FIND HIM

1620 GRANT

294 - 9805

Colorado

USA

FOUND

LOST FERRET

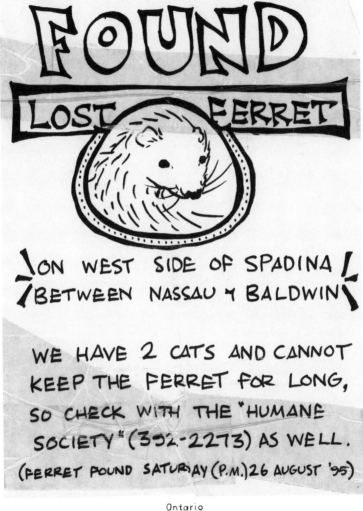

ON WEST SIDE OF SPADINA BETWEEN NASSAU & BALDWIN

WE HAVE 2 CATS AND CANNOT KEEP THE FERRET FOR LONG, SO CHECK WITH THE "HUMANE SOCIETY" (392-2273) AS WELL.

(FERRET FOUND SATURDAY (P.M.) 26 AUGUST '95)

Ontario

`CANADA`

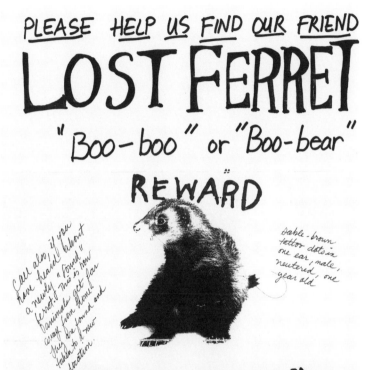

PLEASE HELP US FIND OUR FRIEND

LOST FERRET

"Boo-boo" or "Boo-bear"

REWARD

Call also, if you have heard about a newly "found" ferret. This is how animals get far away from home, they are found and taken to a new location.

Sable-brown tattoo dots in one ear, male, neutered, one year old

LAST SEEN @ HOME FEB 21ST 8³⁰ PM.
MAY HAVE ESCAPED VIA THE FRONT DOOR
OF 14th AVE. NE. IF YOU SEE HIM
PLEASE TRY TO CAPTURE HIM. PEOPLE-
FRIENDLY. WILL NOT BITE.

California

USA

LOST. Ferret

COLOR. Black

AND WHITE.

NAME

"Lil".

"CALL... 781-032

Washington

USA

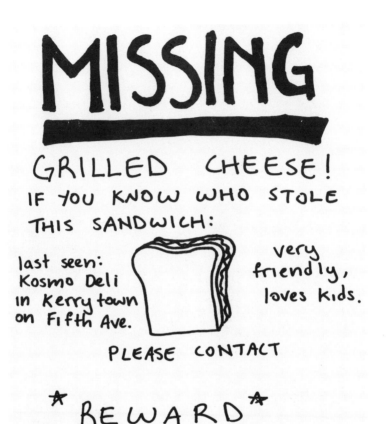

MISSING

GRILLED CHEESE!

IF YOU KNOW WHO STOLE THIS SANDWICH:

last seen:
Kosmo Deli
in Kerrytown
on Fifth Ave.

very
friendly,
loves kids.

PLEASE CONTACT

REWARD

DESPERATELY SEEKING SANDWICH. PLEASE HELP

Michigan

USA

Missing Pet Poster Tips

Millions of pets go missing every year in the United States alone. Recovery rates are dismal: over ninety percent of cats and dogs are never found. Missing pet posters are the best way to recover a lost animal.

What To Put on Your Poster:

HEADING: "Lost Cat," for example—in large, legible lettering.

DESCRIPTION: basic details include breed, color, eye color, size, gender, age, markings, etc. Withhold a few details to verify that any caller claiming to have recovered your pet is not trying to scam reward money.

NAME: some people advise not to reveal the name of your pet. A pet thief could gain the trust of your pet with this information.

TAGS: the type of collar, tags, microchip, tattoo, etc.

TIME AND LOCATION: Where was your pet lost, and how?

CONTACT INFORMATION: your name and a phone number, but not your address.

PHOTOGRAPH: include a picture of your pet, or of an animal that looks like yours. Full body is best.

REWARD: rewards will motivate people to take the time to look in their garage or shed, but don't list the amount—it may be perceived as inadequate. If the reward is large, you may get callers trying to scam the money out of you.

Photocopies work well and are cheap. If you can afford color copies, even better. Don't print your posters on an ink-jet printer: if it rains or snows the ink will run.

The more posters you put up, the better your chances. Telephone poles are the best places to post, though some municipalities don't allow posters and flyers on public property. Don't staple or nail posters to trees. Try postering neighborhoods your pet may be familiar with. Grocery stores, veterinarian hospitals, pet stores, libraries, laundromats, convenience stores, and playgrounds are all high-traffic locations. Always ask for permission to post inside these locations. While posting, keep an eye out for a "Found" poster someone else may have made. Place your posters at eye level for both pedestrians and motorists. Keep returning to check if the posters are still where you put them, as people frequently remove them for a variety of reasons. Replace worn or faded posters—old-looking posters are easily overlooked.

If someone calls with a sighting, find out where they're calling from and saturate that area with new posters. If someone contacts you claiming to have found your pet, you should be the one asking questions—you need to be sure they really have seen or found your pet. Don't give out too much descriptive information over the telephone: you may get callers who are only interested in collecting reward money. If your search was successful, take all the posters down. It's neighborly.

41% of US pet owners keep a picture of their pet in their home

17% keep a picture of their pet in their wallet

13,000,000 cats have their birthdays celebrated

16% of dogs in the US sleep on top of their owner's bed

There are an equal number of male and female dogs owned in the US

20% of owned dogs were adopted from an animal shelter

For every human born, 7 puppies and kittens are born

28,539,216 dog owners purchase Christmas gifts for their dogs

95% of dog owners hug their dogs daily

Best watchdog: rottweiler

Worst watchdog: bloodhound

One female cat and her offspring can produce 420,000 cats in 7 years

Annual US spending for pets: $28.5 billion

20% of US dog owners love their dogs more than their best friend

6 % are more attached to their dogs than their spouse

83% of pet owners acquired their pet for companionship

Largest recorded litter: 23 American foxhounds born June 19th, 1944

The most common pet name in the US: Max

Sam, Lady, Smokey, and Bear rank among the next most popular